YOU can draw a KANGAROO

In the eyes of people from other countries some
Australian animals look a bit mixed up. For example, people used to birds
being birds and animals being animals find something very
quaint in the lovable platypus of Australia. which has a duck's bill
and webbed feet. swims, lives in a burrow and lays eggs.
Australia is also the home of a swan which is black, the lyrebird which
imitates perfectly the calls of other birds, the kangaroo
which moves in ten-metre bounds, the mud-skipper fish which knows the extraordinary
trick of breathing air through its lungs and oxygen through
its tail, the sleepy koala, the frilled lizard which
raises a large cape around its neck when it wants to look horrible,
and the companies of brolgas, the long-legged birds that dance
in square-dance patterns on the northern swamps and plains.
Because these Australians are quaint or lovable or just because
they make simple pictures this drawing book has
been devised, with sketches showing how each is built up from
simple forms and verses which tell you something
about the subject and follow the steps of its construction.
Any child or adult who can doodle on a blotter or telephone pad can
build up the kangaroo or the boobook owl as they are drawn here.
It is best to begin at the beginning. The drawings have been arranged
in order of their difficulty. There is nothing hard about drawing the
koala or boobook owl, but to reach lyrebird standard is highly
commendable. It should be reassuring when you finish your picture to
reflect on the conclusion of the poem about the platypus:

And if the upshot of your skill
Seems an impossibility,
It almost certainly is he!

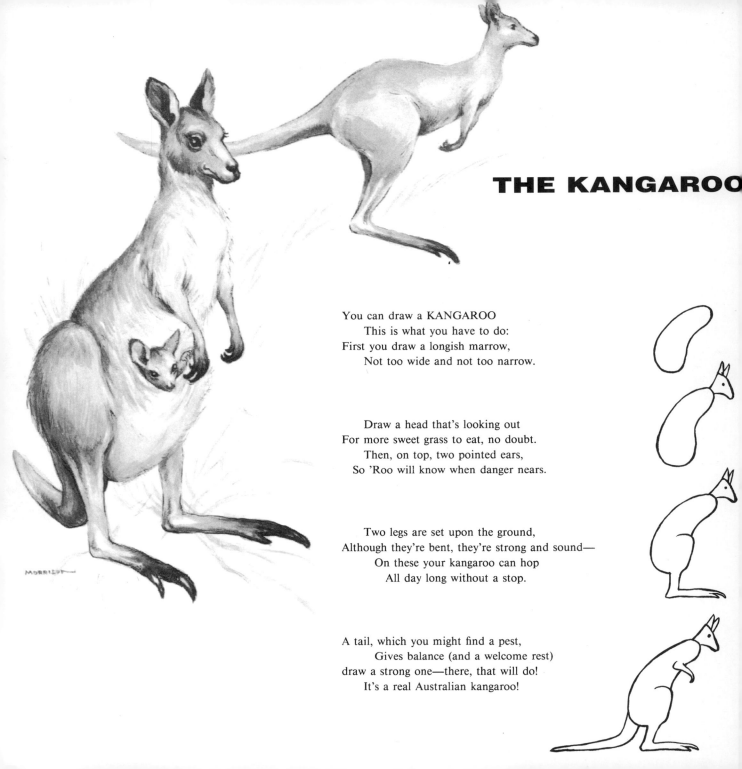

THE KANGAROO

You can draw a KANGAROO
 This is what you have to do:
First you draw a longish marrow,
 Not too wide and not too narrow.

 Draw a head that's looking out
For more sweet grass to eat, no doubt.
 Then, on top, two pointed ears,
 So 'Roo will know when danger nears.

 Two legs are set upon the ground,
Although they're bent, they're strong and sound—
 On these your kangaroo can hop
 All day long without a stop.

A tail, which you might find a pest,
 Gives balance (and a welcome rest)
draw a strong one—there, that will do!
 It's a real Australian kangaroo!

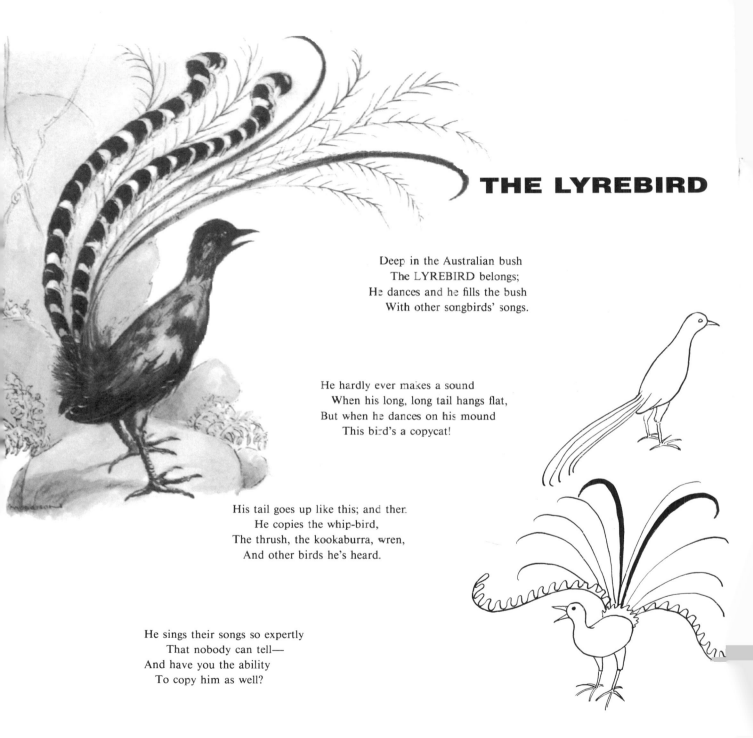

THE LYREBIRD

Deep in the Australian bush
The LYREBIRD belongs;
He dances and he fills the bush
With other songbirds' songs.

He hardly ever makes a sound
When his long, long tail hangs flat,
But when he dances on his mound
This bird's a copycat!

His tail goes up like this; and then
He copies the whip-bird,
The thrush, the kookaburra, wren,
And other birds he's heard.

He sings their songs so expertly
That nobody can tell—
And have you the ability
To copy him as well?

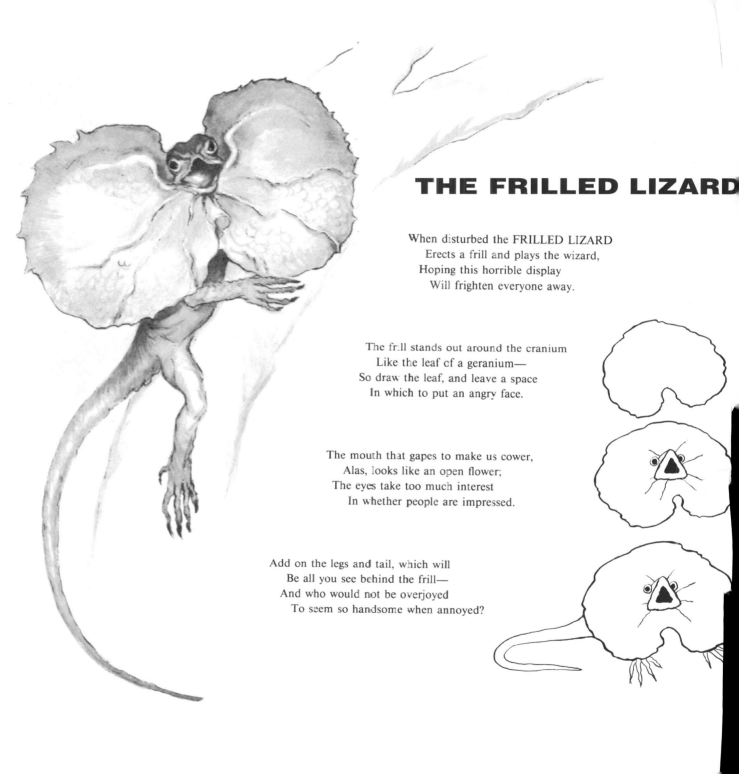

THE FRILLED LIZARD

When disturbed the FRILLED LIZARD
Erects a frill and plays the wizard,
Hoping this horrible display
Will frighten everyone away.

The frill stands out around the cranium
Like the leaf of a geranium—
So draw the leaf, and leave a space
In which to put an angry face.

The mouth that gapes to make us cower,
Alas, looks like an open flower;
The eyes take too much interest
In whether people are impressed.

Add on the legs and tail, which will
Be all you see behind the frill—
And who would not be overjoyed
To seem so handsome when annoyed?

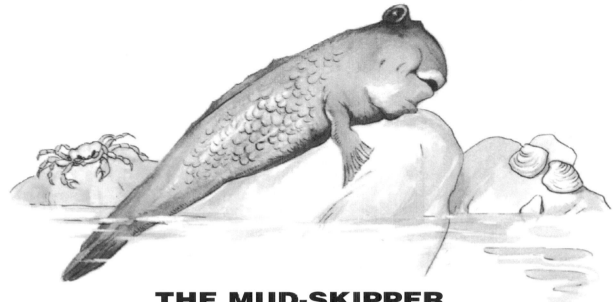

THE MUD-SKIPPER

Over mud, over water, skip the little MUD-SKIPPERS
With a wriggle and a push from their strong front-flippers;
They breathe in the air through their lungs like men
While their tails in the water filter ox-y-gen.

The professors regard them as a bit of a sensation,
So they're worthy of a mark of ex-clam-ation!
But you have to draw them sloping, and you have to put the stop,
Instead of at the bottom, somewhere near the top.

For the stop is an eye; they can swivel one around
At an insect in the air, while the other sweeps the ground;
At the first glimpse they get of an insect or a crab
They gulp it with a skip and wriggle and a grab.

Now draw in flippers, tails and then faces
 And put the skippers on a rock with water at their bases
With tails in the water as they watch all fronts,
 Happily breathing through both ends at once.

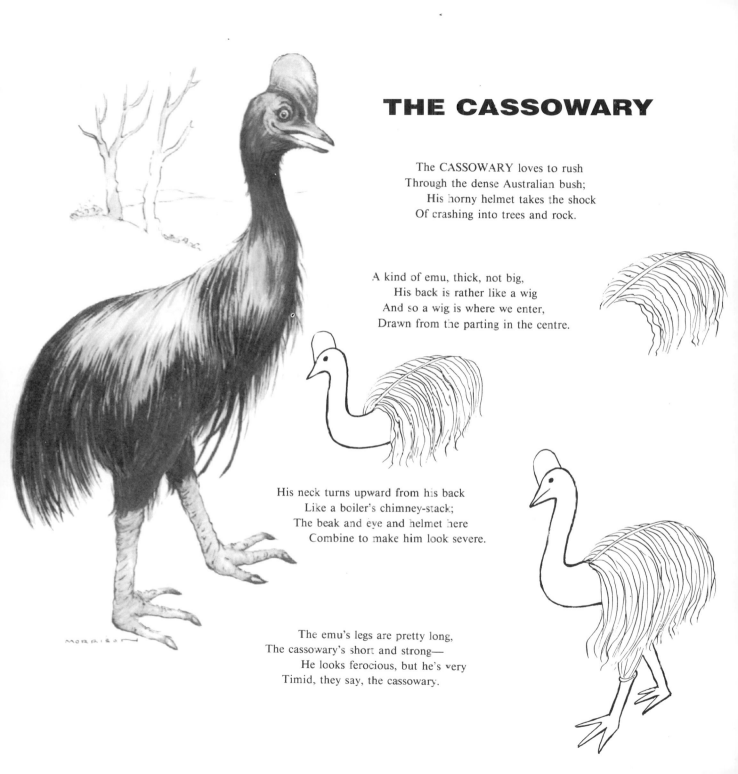

THE CASSOWARY

The CASSOWARY loves to rush
Through the dense Australian bush;
His horny helmet takes the shock
Of crashing into trees and rock.

A kind of emu, thick, not big,
His back is rather like a wig
And so a wig is where we enter,
Drawn from the parting in the centre.

His neck turns upward from his back
Like a boiler's chimney-stack;
The beak and eye and helmet here
Combine to make him look severe.

The emu's legs are pretty long,
The cassowary's short and strong—
He looks ferocious, but he's very
Timid, they say, the cassowary.

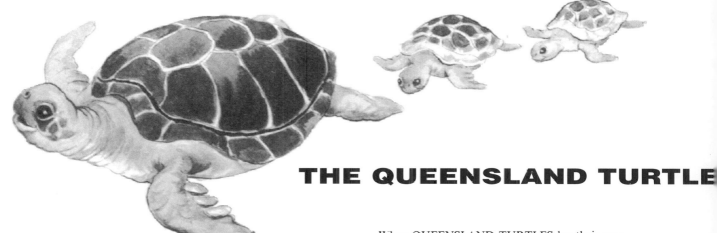

THE QUEENSLAND TURTLE

When QUEENSLAND TURTLES lay their eggs
They wade ashore on flipper-legs;
 Then tourists mount upon them, and
Ride on their backs along the sand.

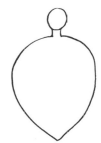

The turtle's back and head are brown,
Shaped like the Ace of Spades turned down:
 The turtle's head, you see, is made
Out of the handle of the spade.

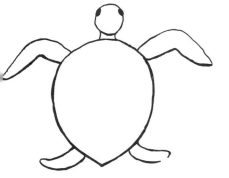

The two front flippers spread out wide
Like boomerangs on either side;
The two hind ones are short, and they
 Incline to turn the other way.

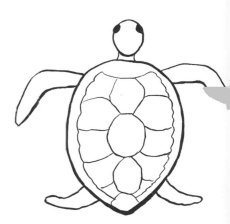

The flippers and the back as well
 Must now be marked like tortoise-shell
And done from life, or done from books,
 It's not as easy as it looks.

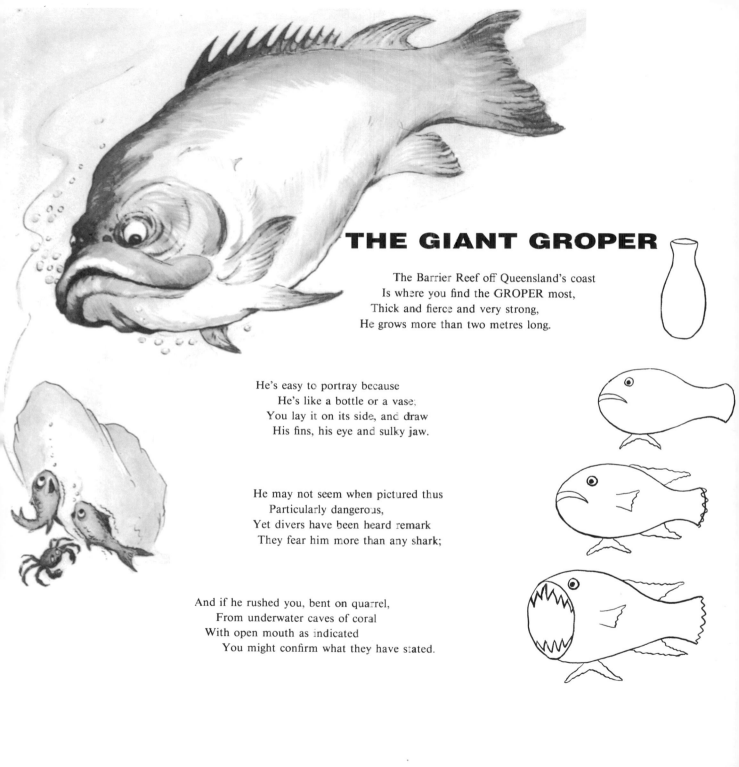

THE GIANT GROPER

The Barrier Reef off Queensland's coast
Is where you find the GROPER most,
Thick and fierce and very strong,
He grows more than two metres long.

He's easy to portray because
He's like a bottle or a vase;
You lay it on its side, and draw
His fins, his eye and sulky jaw.

He may not seem when pictured thus
Particularly dangerous,
Yet divers have been heard remark
They fear him more than any shark;

And if he rushed you, bent on quarrel,
From underwater caves of coral
With open mouth as indicated
You might confirm what they have stated.

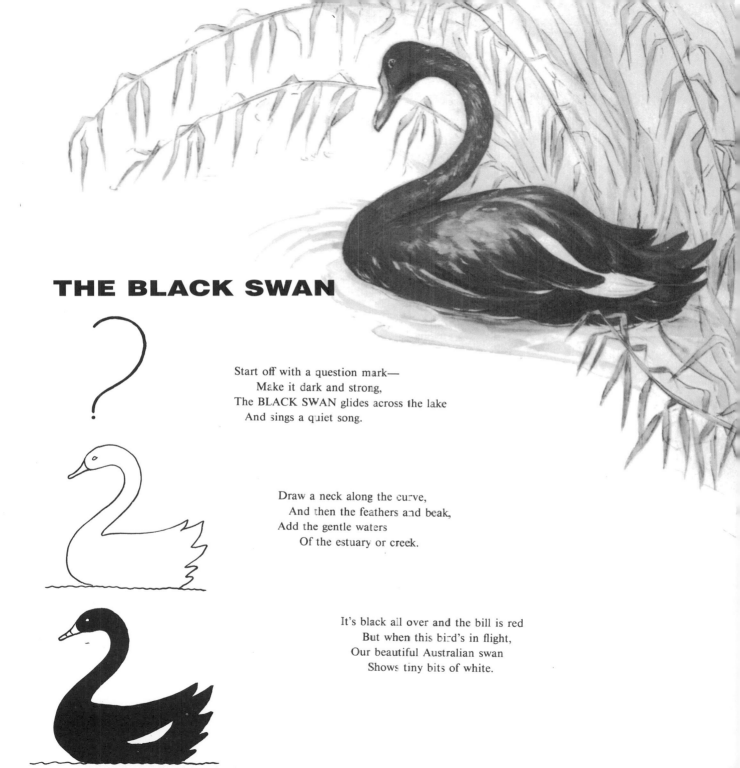

THE BLACK SWAN

Start off with a question mark—
 Make it dark and strong,
The BLACK SWAN glides across the lake
 And sings a quiet song.

Draw a neck along the curve,
 And then the feathers and beak,
Add the gentle waters
 Of the estuary or creek.

It's black all over and the bill is red
 But when this bird's in flight,
Our beautiful Australian swan
 Shows tiny bits of white.

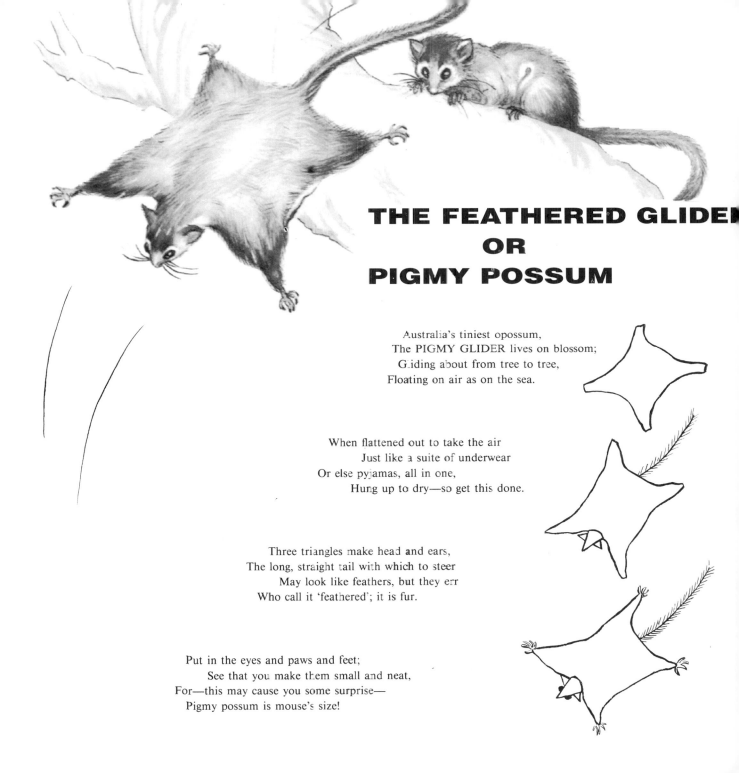

THE FEATHERED GLIDER
OR
PIGMY POSSUM

Australia's tiniest opossum,
The PIGMY GLIDER lives on blossom;
Gliding about from tree to tree,
Floating on air as on the sea.

When flattened out to take the air
Just like a suite of underwear
Or else pyjamas, all in one,
Hung up to dry—so get this done.

Three triangles make head and ears,
The long, straight tail with which to steer
May look like feathers, but they err
Who call it 'feathered'; it is fur.

Put in the eyes and paws and feet;
See that you make them small and neat,
For—this may cause you some surprise—
Pigmy possum is mouse's size!

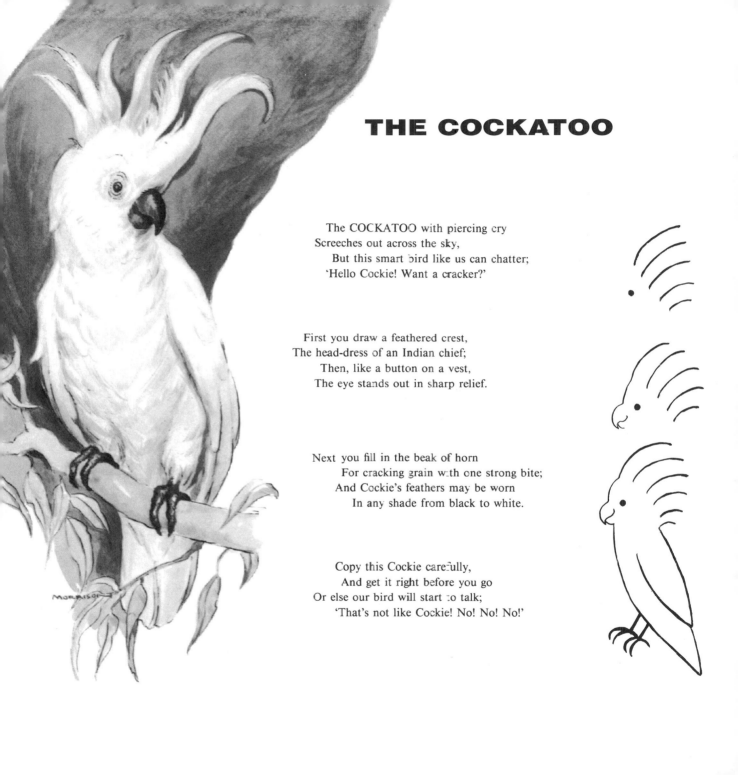

THE COCKATOO

The COCKATOO with piercing cry
Screeches out across the sky,
 But this smart bird like us can chatter;
 'Hello Cockie! Want a cracker?'

First you draw a feathered crest,
The head-dress of an Indian chief;
 Then, like a button on a vest,
 The eye stands out in sharp relief.

Next you fill in the beak of horn
 For cracking grain with one strong bite;
And Cockie's feathers may be worn
 In any shade from black to white.

Copy this Cockie carefully,
 And get it right before you go
Or else our bird will start to talk;
 'That's not like Cockie! No! No! No!'

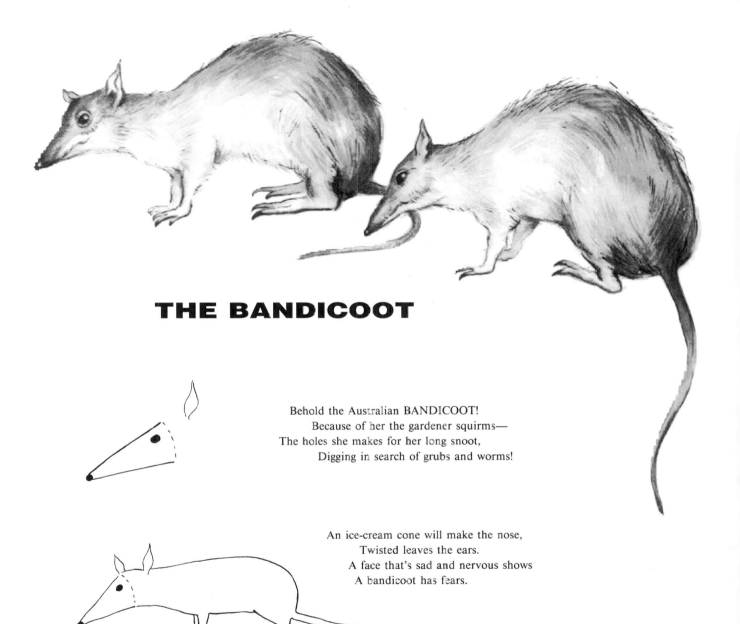

THE BANDICOOT

Behold the Australian BANDICOOT!
Because of her the gardener squirms—
The holes she makes for her long snoot,
Digging in search of grubs and worms!

An ice-cream cone will make the nose,
Twisted leaves the ears.
A face that's sad and nervous shows
A bandicoot has fears.

Suppose an ice-cream-eating rat,
Nose in a cone, could not get out—
The bandicoot would look like that.
Very worried, there's no doubt.

THE BROLGA

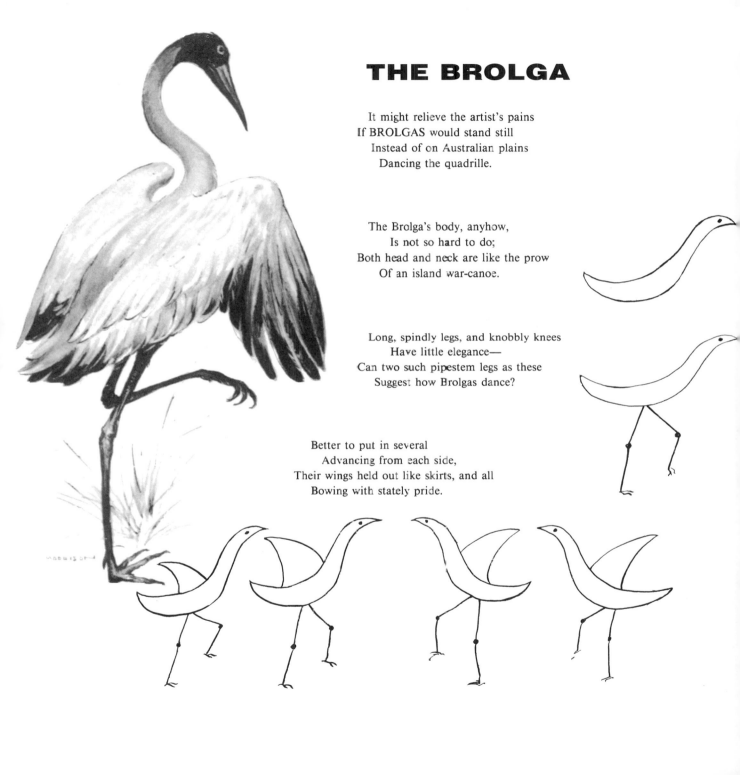

It might relieve the artist's pains
If BROLGAS would stand still
 Instead of on Australian plains
 Dancing the quadrille.

The Brolga's body, anyhow,
 Is not so hard to do;
Both head and neck are like the prow
 Of an island war-canoe.

Long, spindly legs, and knobbly knees
 Have little elegance—
Can two such pipestem legs as these
 Suggest how Brolgas dance?

Better to put in several
 Advancing from each side,
Their wings held out like skirts, and all
 Bowing with stately pride.

THE BOOBOOK OWL

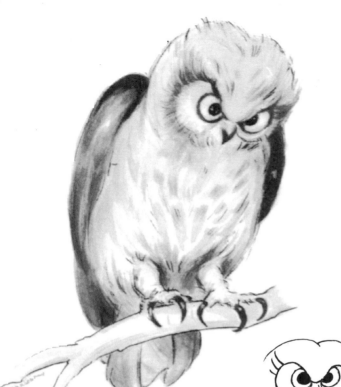

This curious Australian OWL
Established in a gum-tree fork
 Emits a weird and mournful howl:
 'Boo-book!' she cries. 'Mo-poke! More-pork!'

Nobody knows why this is so,
 But when you draw her, make a start
By sympathising with her woe
 And giving her a broken heart.

Then you put in the large, crossed eyes,
 Their sort of sly and thoughtful look,
And the small beak through which she cries:
 'Mo-poke! More-pork! Boo-book! Boo-book!'

You add her wings and claws, and then
 Her tail is finished with a stroke—
Now hear her cry just once again:
 'More-pork! Boo-book! Mo-poke! Mo-poke!'

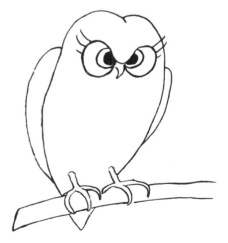

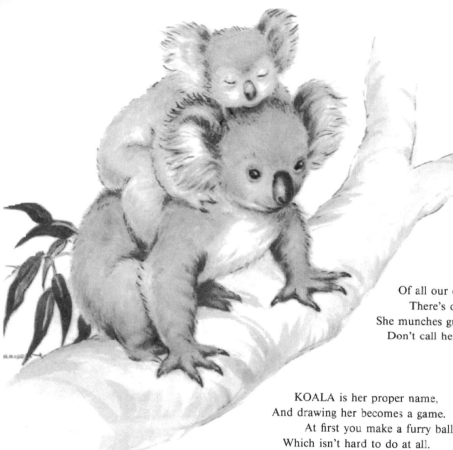

THE KOALA

Of all our creatures east to west
 There's one that's known and loved the best,
She munches gum leaves all day long,
 Don't call her a bear or you'll be wrong!

KOALA is her proper name,
And drawing her becomes a game.
 At first you make a furry ball,
Which isn't hard to do at all.

Her head is like another ball,
Her fluffy ears are round and small,
 Her little eyes are keen and bright.
Her button nose is black as night.

Her arms and legs are sturdy, please;
 She needs them thus for climbing trees
Because at night she likes to roam
 Among the treetops of her home.

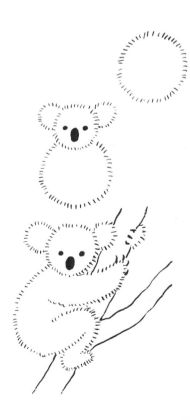

THE KOOKABURRA
or
LAUGHING JACKAS

The bird that all the children cherish more than any other
Is this plump and jolly fellow and they greet him as a brother;
His name is KOOKABURRA, and his fame is in his song
He starts it with a chuckle and he ends by laughing long.

Some call him LAUGHING JACKASS, and he cannot help but grin
If you hear him in the mornings as he laughs the sunrise in.
It isn't hard to draw him, and he's such a cheerful chap
That if it is not like him he will not care a rap.

'Kook! Kook! He! He! Ho! Ho! Ha! Ha!' he'll very likely say
As you add his feet and then his wings and let him fly away.
But though he is so jolly he is very much awake
To pounce upon his favourite food—a nasty, wriggly snake.

You hear the swish of his strong wings as from a tree he swoops
To seize a snake that turns and twists and curls itself in hoops;
But Jacky grabs it firmly and never lets it drop,
Then laughs and laughs and laughs and laughs as if he'd never stop.

THE PELICAN

The food of most birds costs them nil,
But PELICANS don't steal—
They put the fish down in their bill
Before they have a meal.

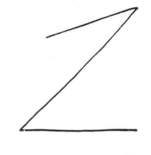

To draw the Australian pelican
You make a Z so vast
That it will be accounted an
Honour for coming last.

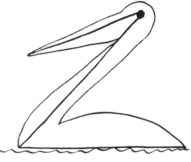

On this big Z, by following the
Straight lines and curves shown here,
The artist very soon will see
The pelican appear.

Why add for completeness' sake,
Webbed feet? Pelicans prefer much more
Graceful swimming on the lake
To waddling on the shore.

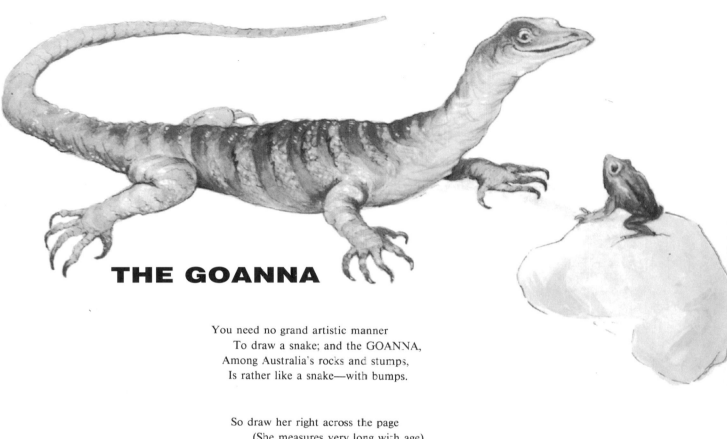

THE GOANNA

You need no grand artistic manner
 To draw a snake; and the GOANNA,
Among Australia's rocks and stumps,
 Is rather like a snake—with bumps.

So draw her right across the page
 (She measures very long with age),
With lizard mouth and lizard head;
 No pointed tail, but square instead.

And then, to hold her off the ground,
Short legs with sharp claws must be found.

Some say she's harmless; others eat her—
 But many more don't want to meet her.

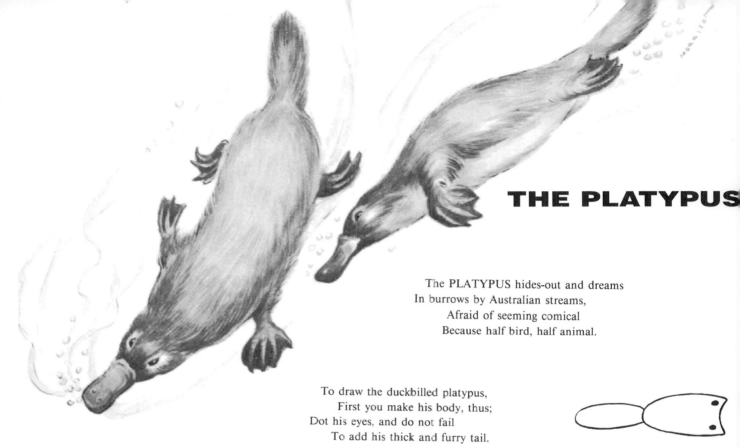

THE PLATYPUS

The PLATYPUS hides-out and dreams
In burrows by Australian streams,
Afraid of seeming comical
Because half bird, half animal.

To draw the duckbilled platypus,
First you make his body, thus;
Dot his eyes, and do not fail
To add his thick and furry tail.

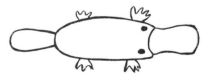

Not fish or fowl, but Nature's whim,
He loves to walk, he loves to swim—
So let invention run amuck
And give him four feet like a duck.

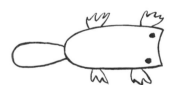

Then put in front a beak or bill,
And if the upshot of your skill
Seems an impossibility,
It almost certainly is he!

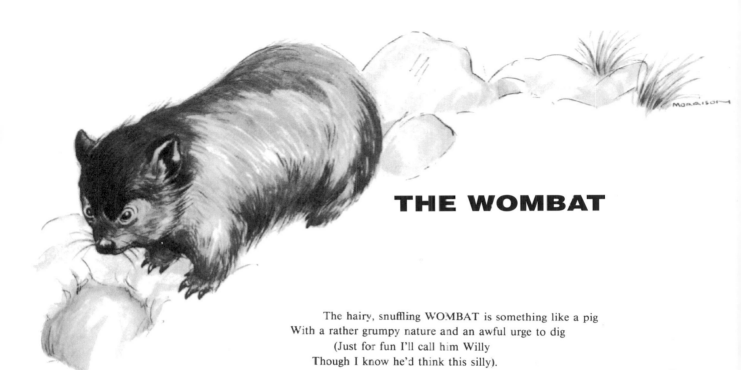

THE WOMBAT

The hairy, snuffling WOMBAT is something like a pig
With a rather grumpy nature and an awful urge to dig
(Just for fun I'll call him Willy
Though I know he'd think this silly).

Now if I were drawing Willy, as perhaps you'd like to do
I'd sketch at first a fattish bean, then add a leg or two
Complete with claws made mighty strong
For moving tons of earth along.

Our Willy's head is not too big, but hard and rather square;
It's made that way so Willy can go burrowing everywhere.
His eyes are very small and dim.
For daylight means bed-time to him.

And if you should chance to wander through the bush some day
You might call on grumpy Willy in his burrow on your way—
But do not be surprised should he
Refuse to ask you in for tea.

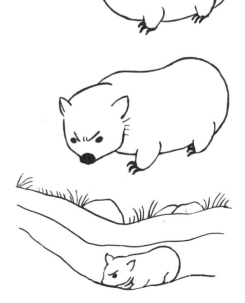

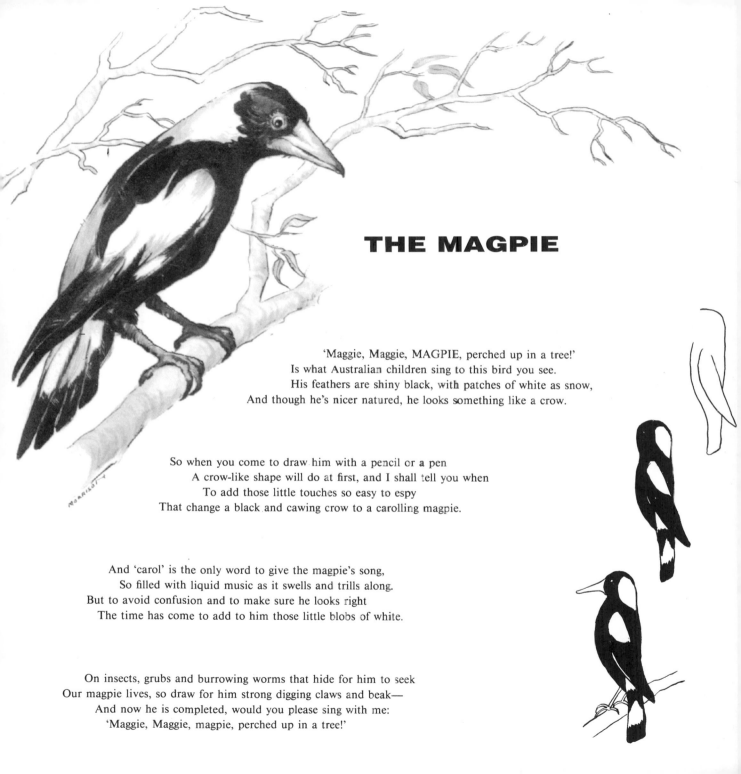

THE MAGPIE

'Maggie, Maggie, MAGPIE, perched up in a tree!'
Is what Australian children sing to this bird you see.
His feathers are shiny black, with patches of white as snow,
And though he's nicer natured, he looks something like a crow.

So when you come to draw him with a pencil or a pen
A crow-like shape will do at first, and I shall tell you when
To add those little touches so easy to espy
That change a black and cawing crow to a carolling magpie.

And 'carol' is the only word to give the magpie's song,
So filled with liquid music as it swells and trills along.
But to avoid confusion and to make sure he looks right
The time has come to add to him those little blobs of white.

On insects, grubs and burrowing worms that hide for him to seek
Our magpie lives, so draw for him strong digging claws and beak—
And now he is completed, would you please sing with me:
'Maggie, Maggie, magpie, perched up in a tree!'

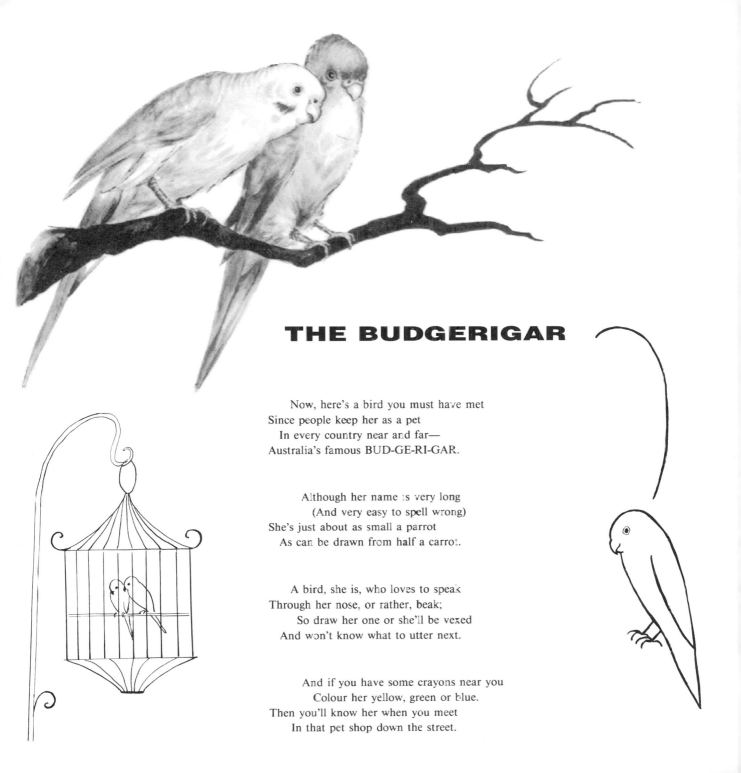

THE BUDGERIGAR

Now, here's a bird you must have met
Since people keep her as a pet
In every country near and far—
Australia's famous BUD-GE-RI-GAR.

Although her name is very long
(And very easy to spell wrong)
She's just about as small a parrot
As can be drawn from half a carrot.

A bird, she is, who loves to speak
Through her nose, or rather, beak;
So draw her one or she'll be vexed
And won't know what to utter next.

And if you have some crayons near you
Colour her yellow, green or blue.
Then you'll know her when you meet
In that pet shop down the street.

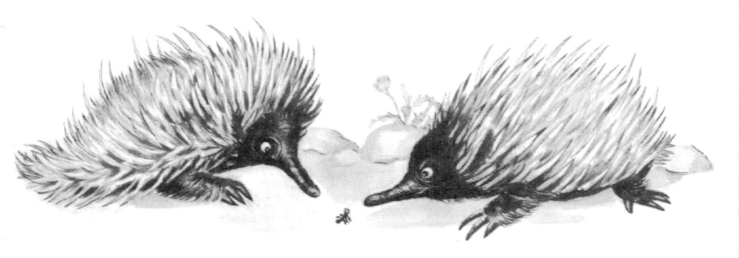

THE ECHIDNA or SPINY ANT-EATER

This funny little fellow, round as a ball of twine,
Looking like a pincushion, or a porcupine,
Is really an ECHIDNA, though many think it neater
To call him by the title of Australian ANT-EATER.

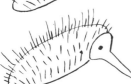

If you feel you'd like to draw him, but can't think how he begins
You only have to sketch a plate and fill it full of pins.
His taste in food is rather odd, or so it seems to me,
For all he eats is lots of ants for breakfast, lunch and tea.

Now ants are often hard to catch, or so I should suppose,
But not for this echidna, who can find them with his nose.
So draw him in a long one that will hide his sticky tongue
That's just ideal for snaring ants, old ones as well as young.

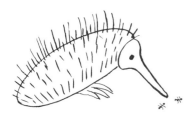

For ants that hide beneath the earth and think it safer there
Echidna's claws are strong and sharp to dig and lay them bare.
So draw his claws; then let him go in search of nests and ants
And watch the way he licks them up with speed and elegance.

THE EMU

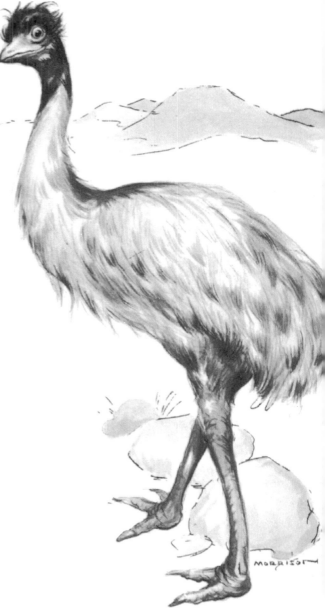

The EMU is the oddest bird,
Her wings are really quite absurd;
She cannot fly, but only run,
Though p'raps to her, that's much more fun.

To draw her you first sketch an egg,
Then add to that a long bare leg.
She cannot run with one, you'll find,
So add another on behind.

Her neck is long and rather thin,
Topped by a head that lacks a chin.
Her feathers are a brownish grey,
So colour them in just that way.

And now you've drawn a famous bird
Of whom all children should have heard,
For she displays her awkward charms
Upon Australia's coat of arms.